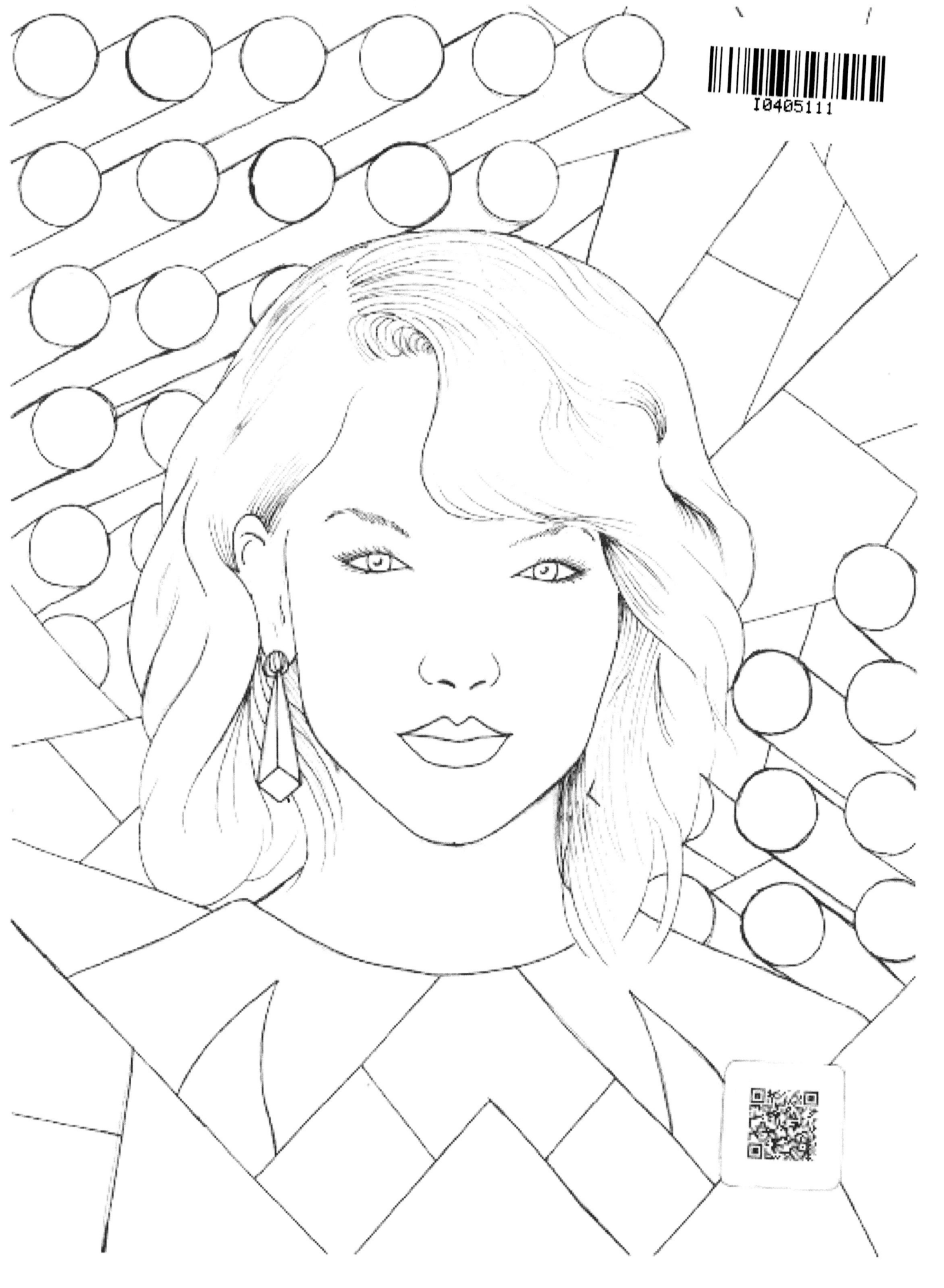

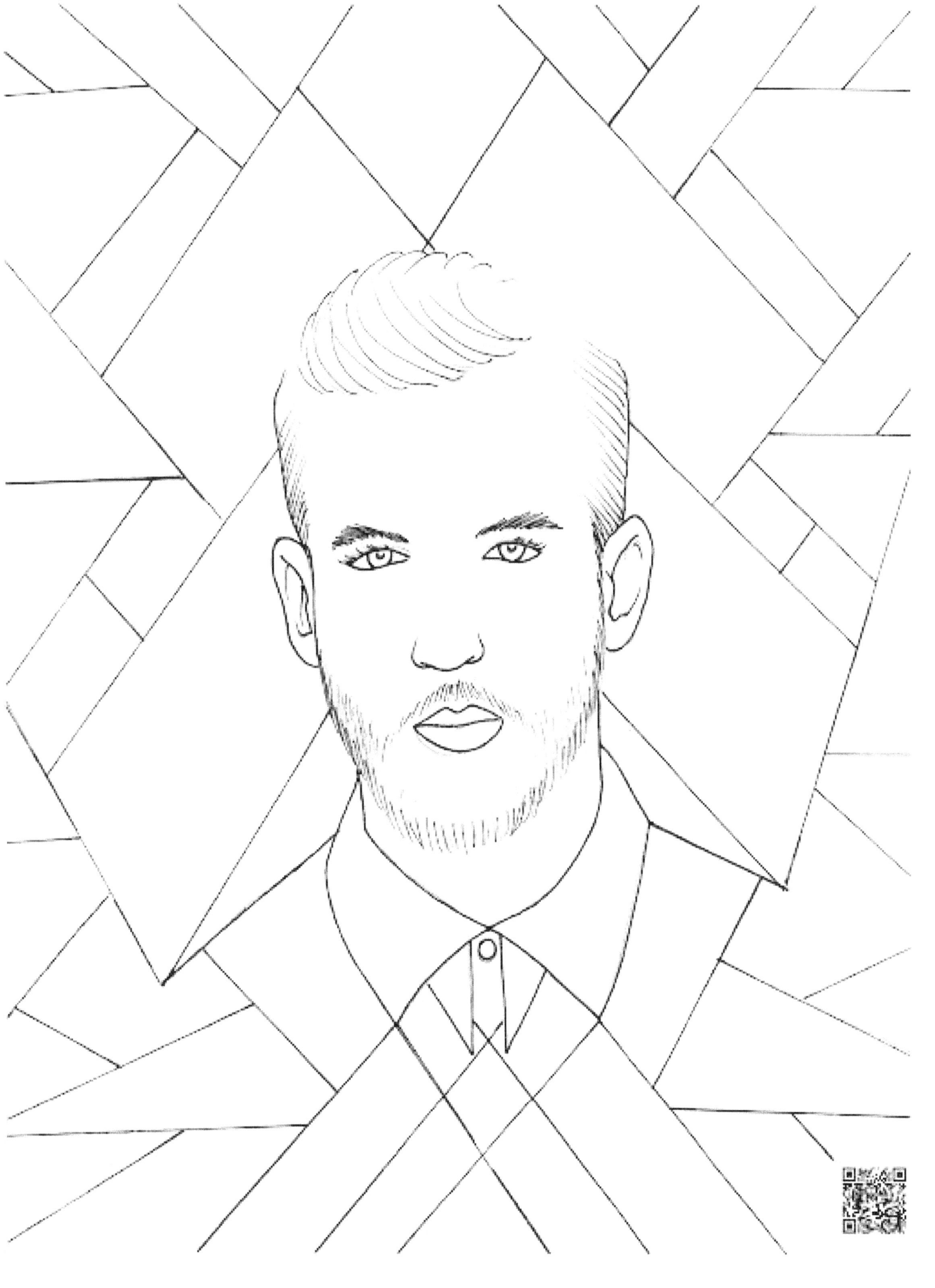

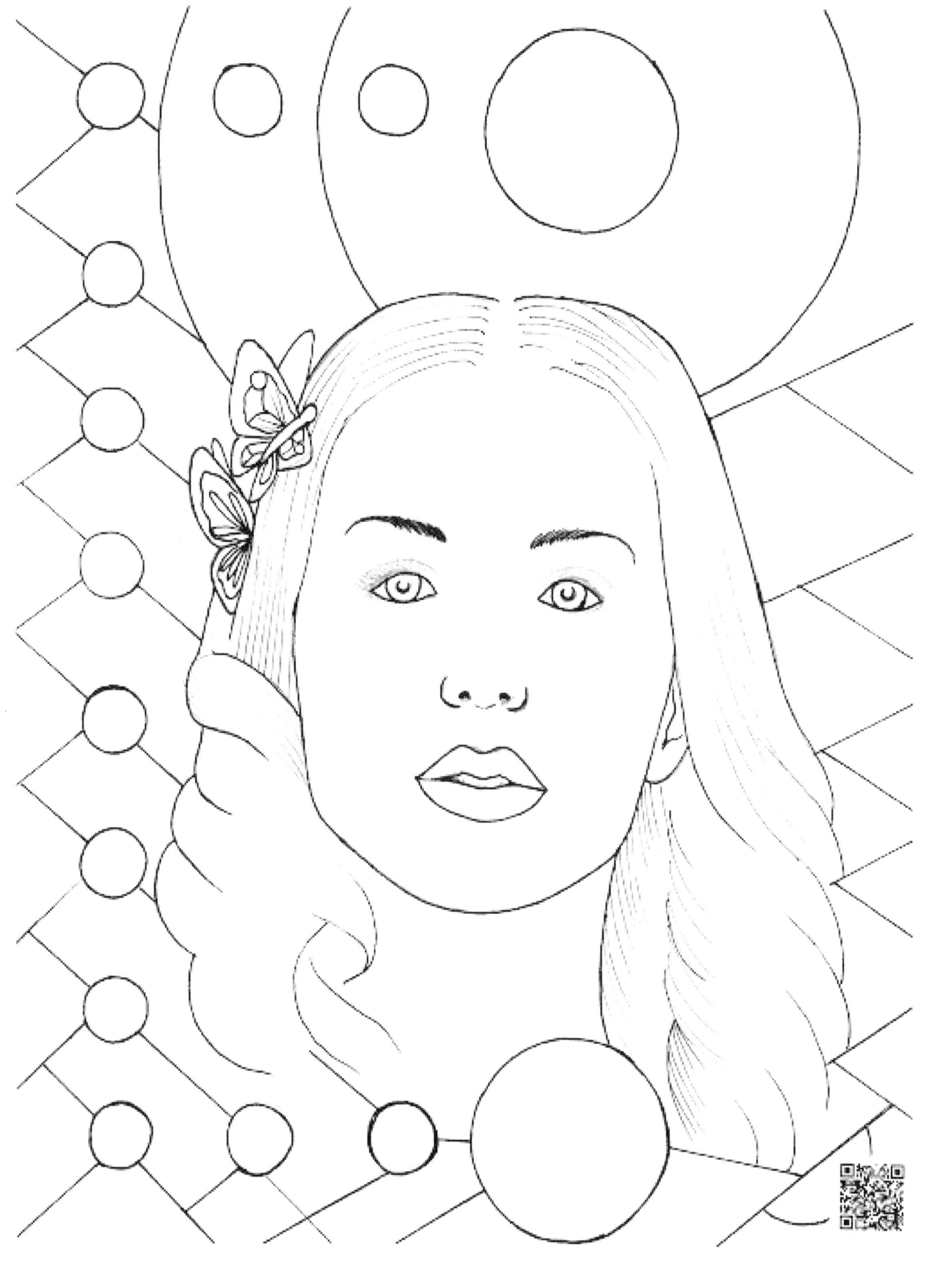

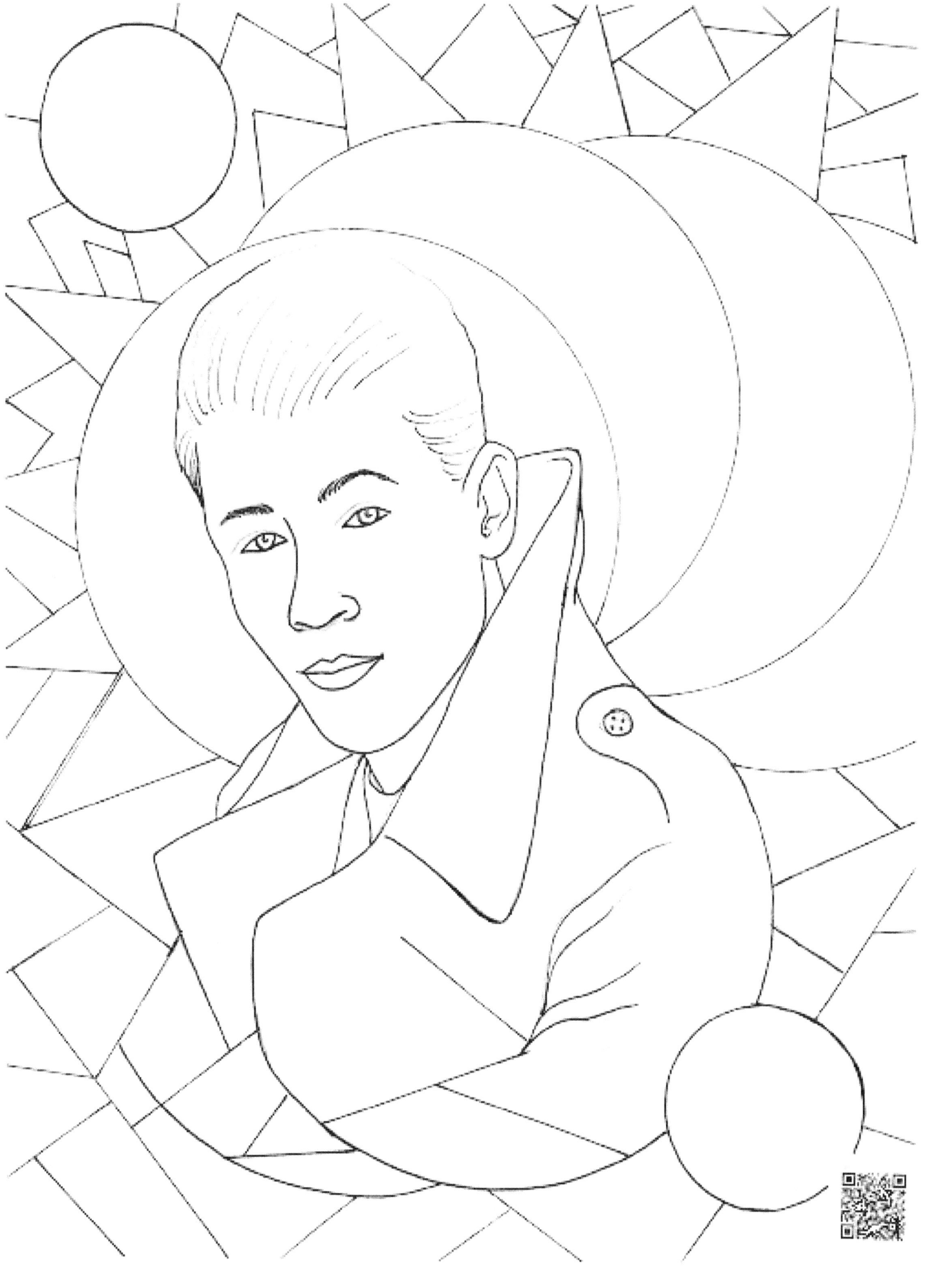

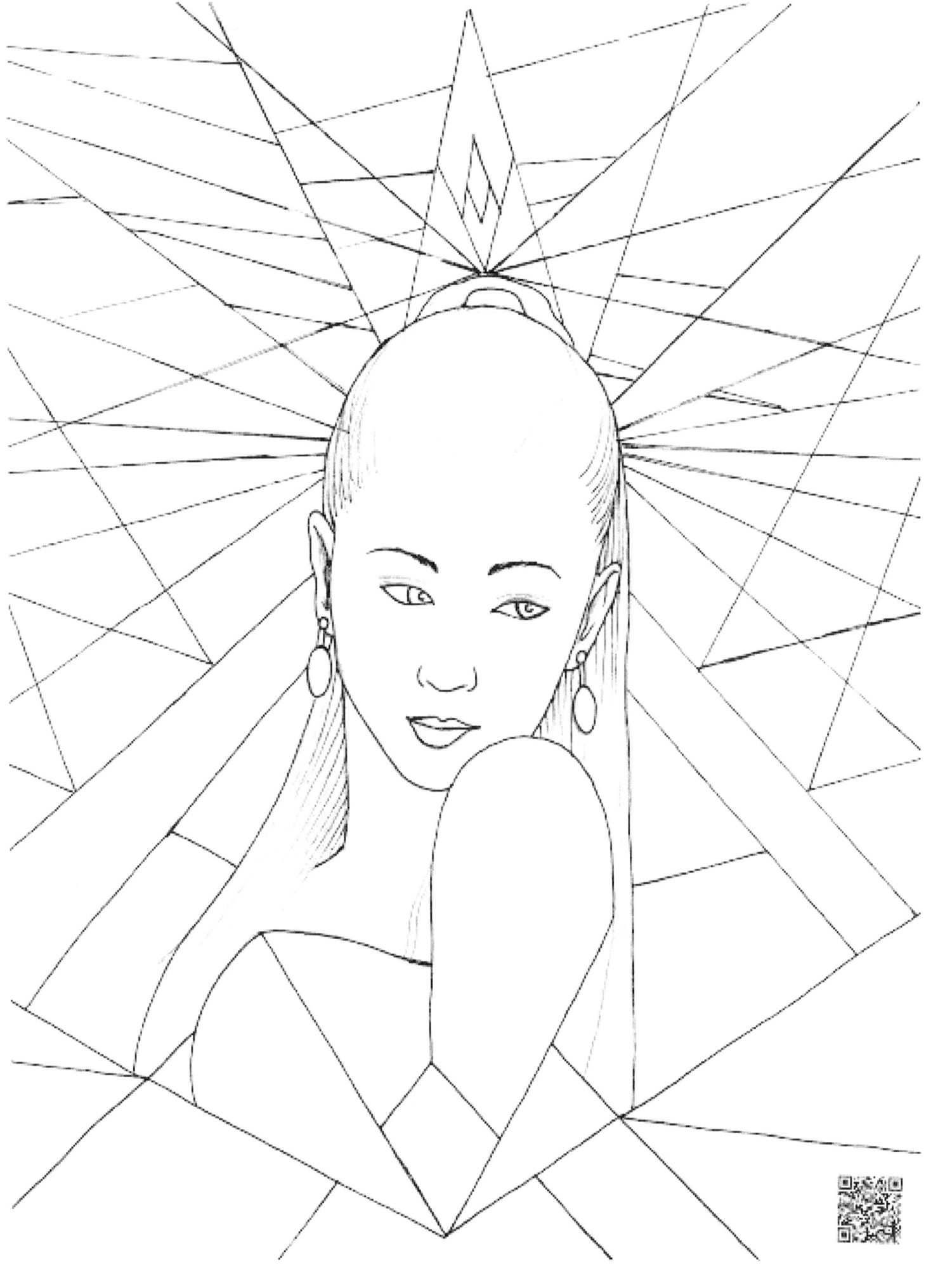

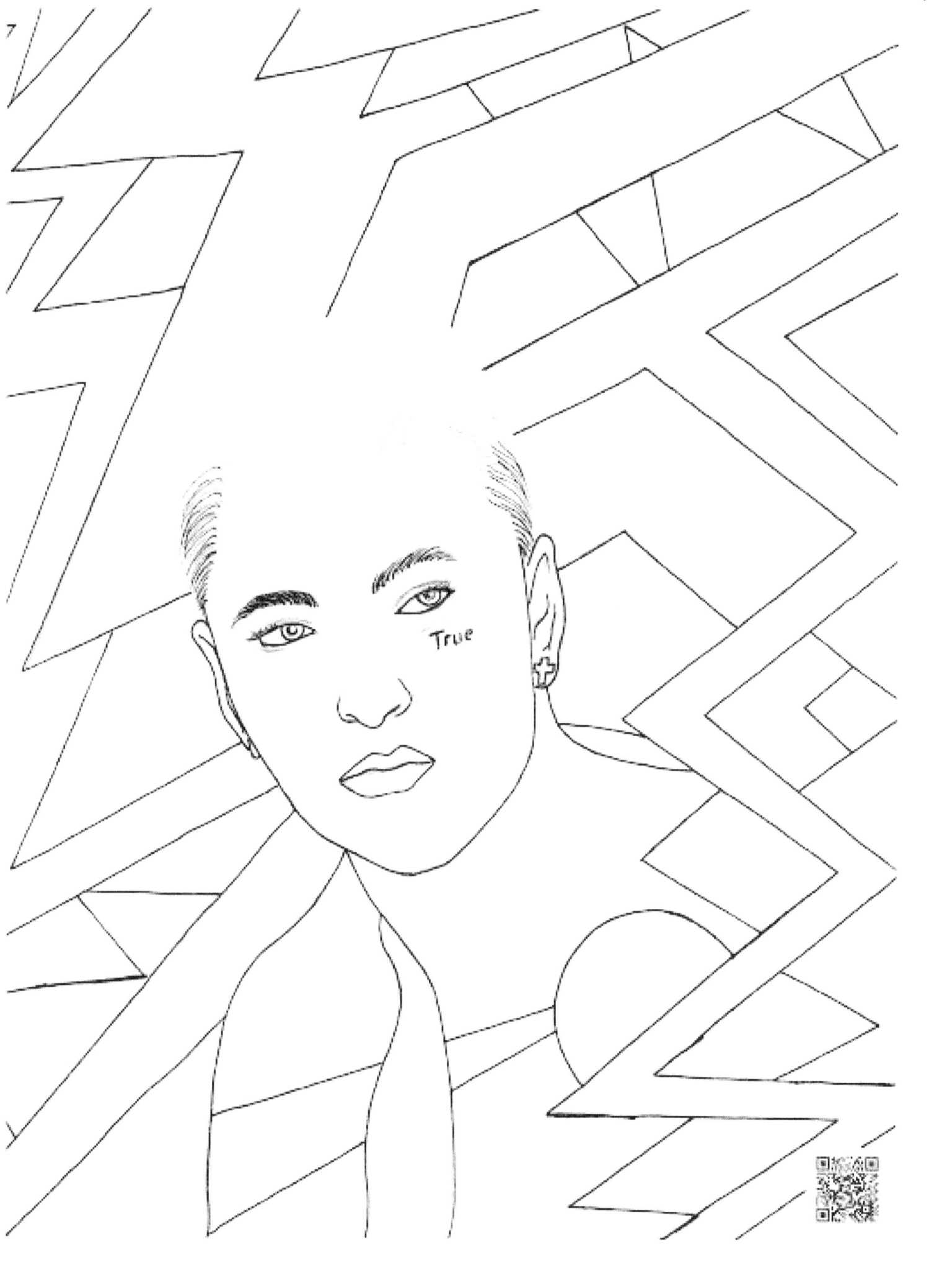

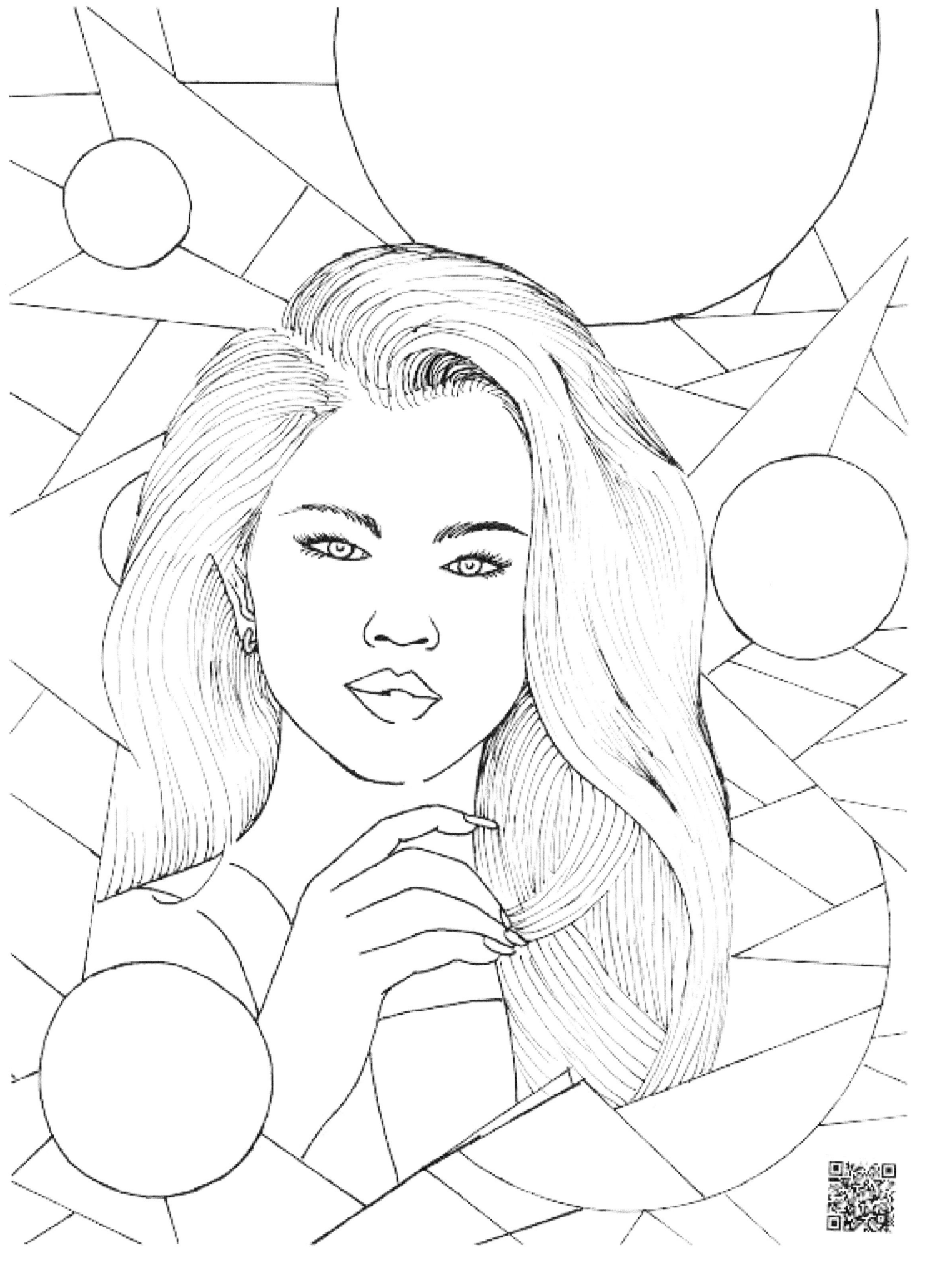

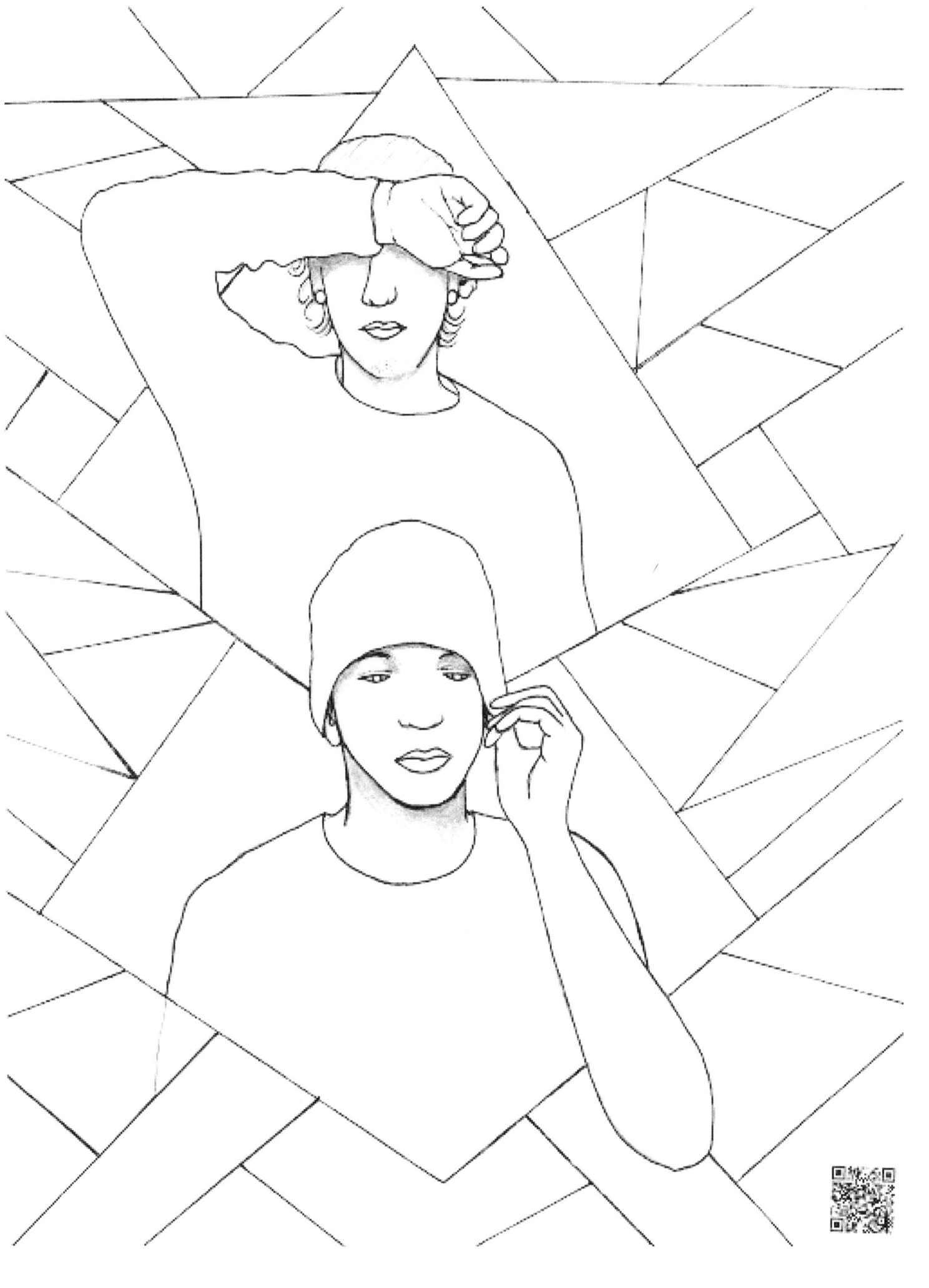

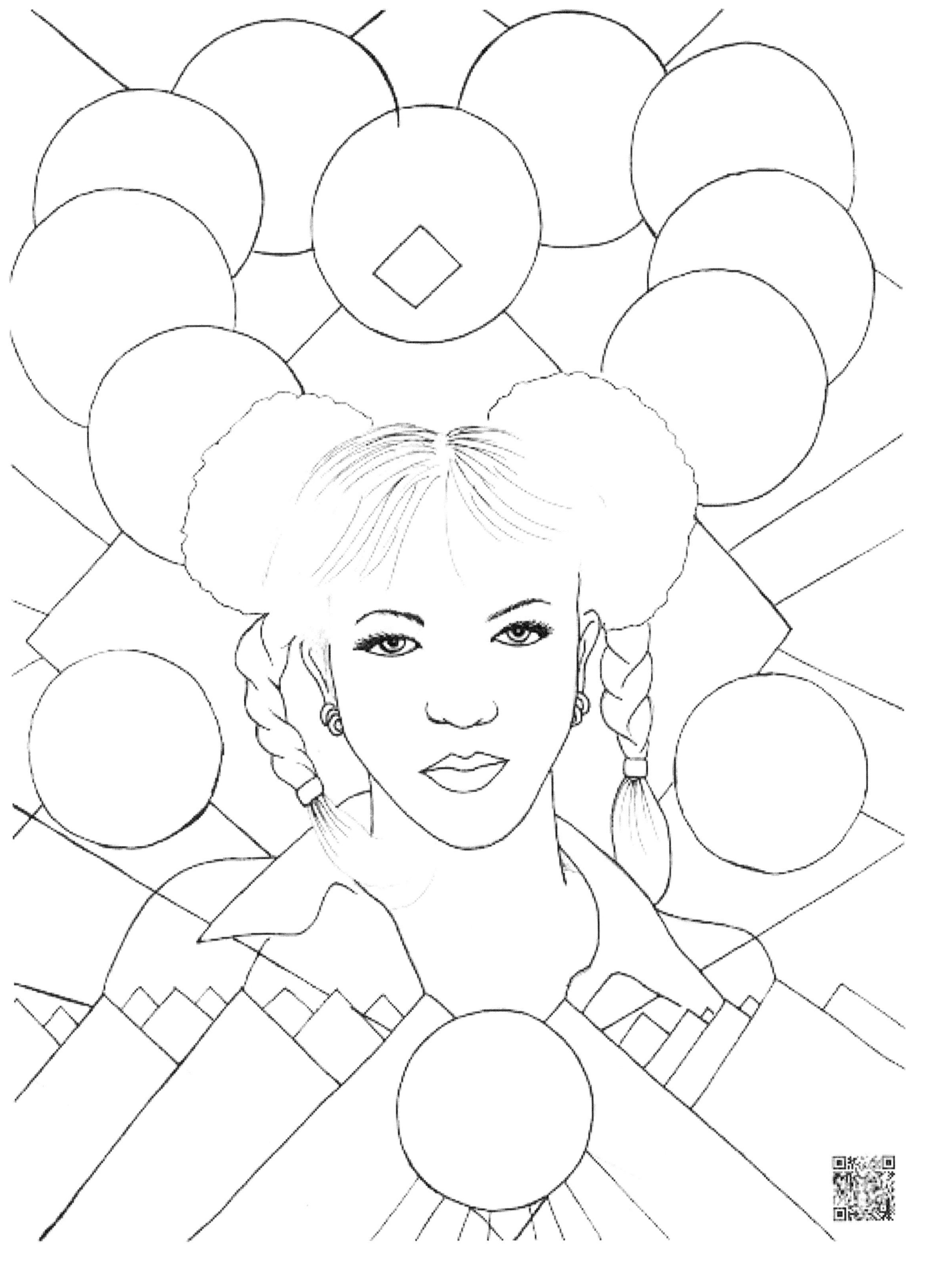

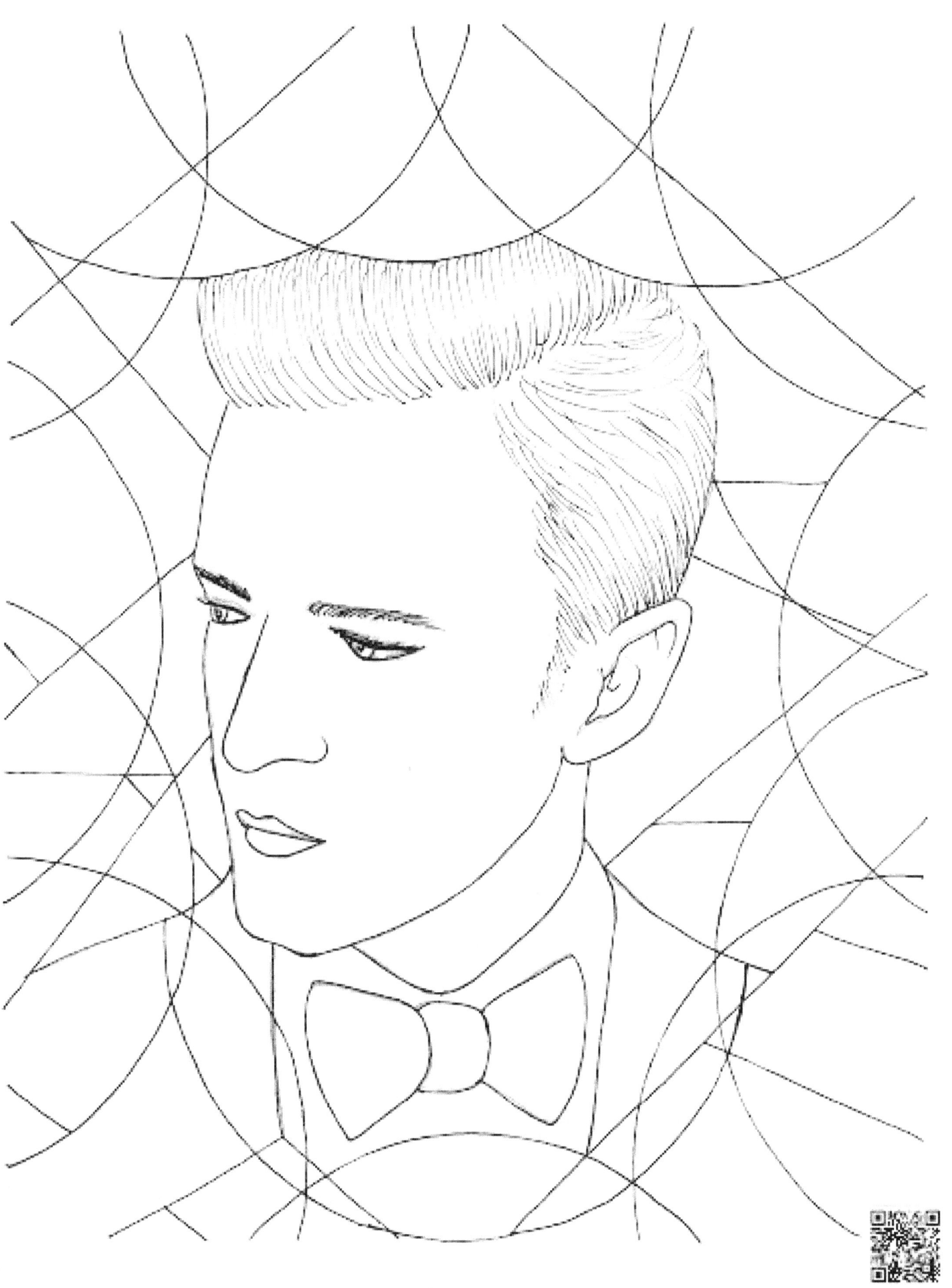

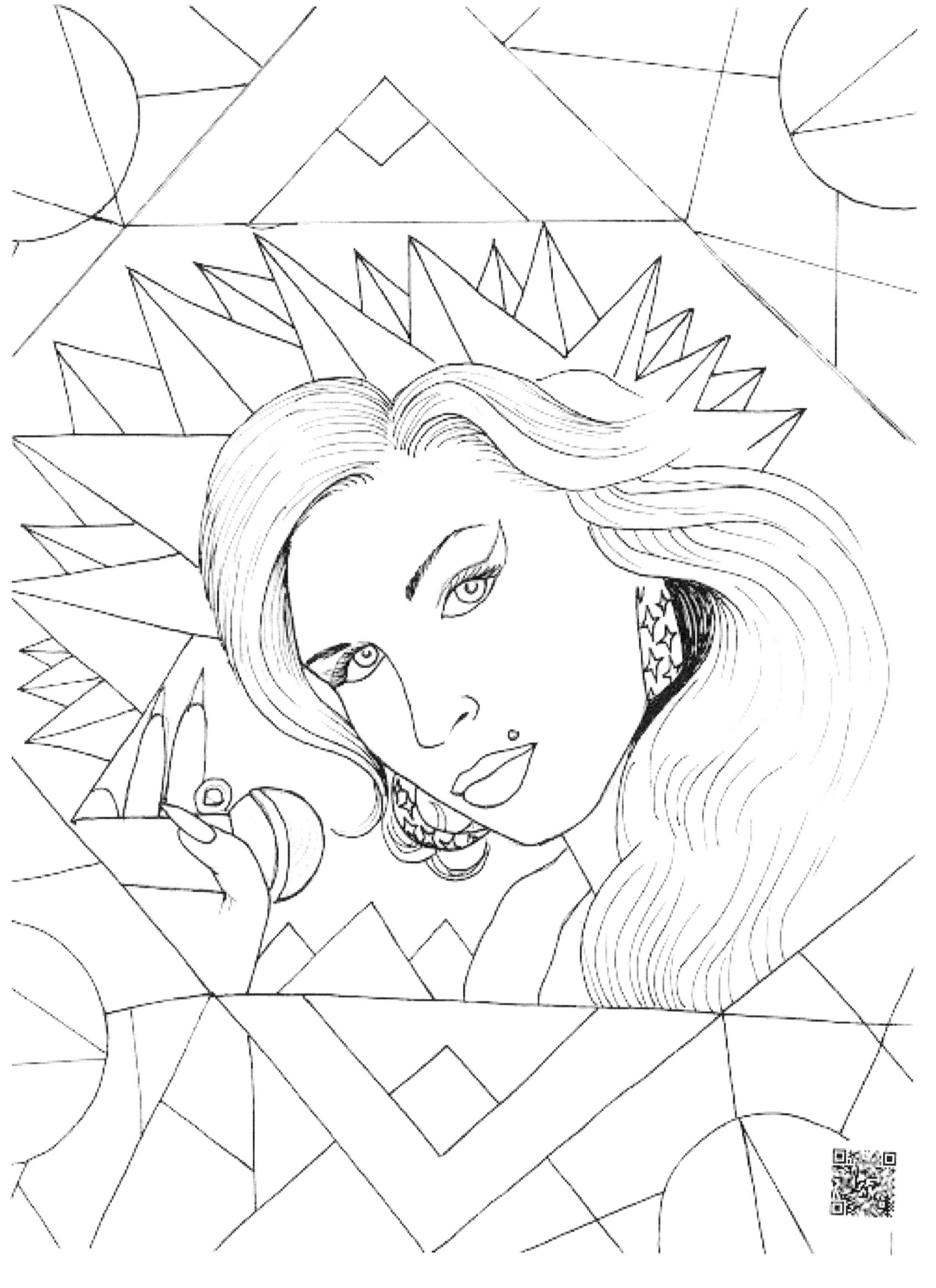

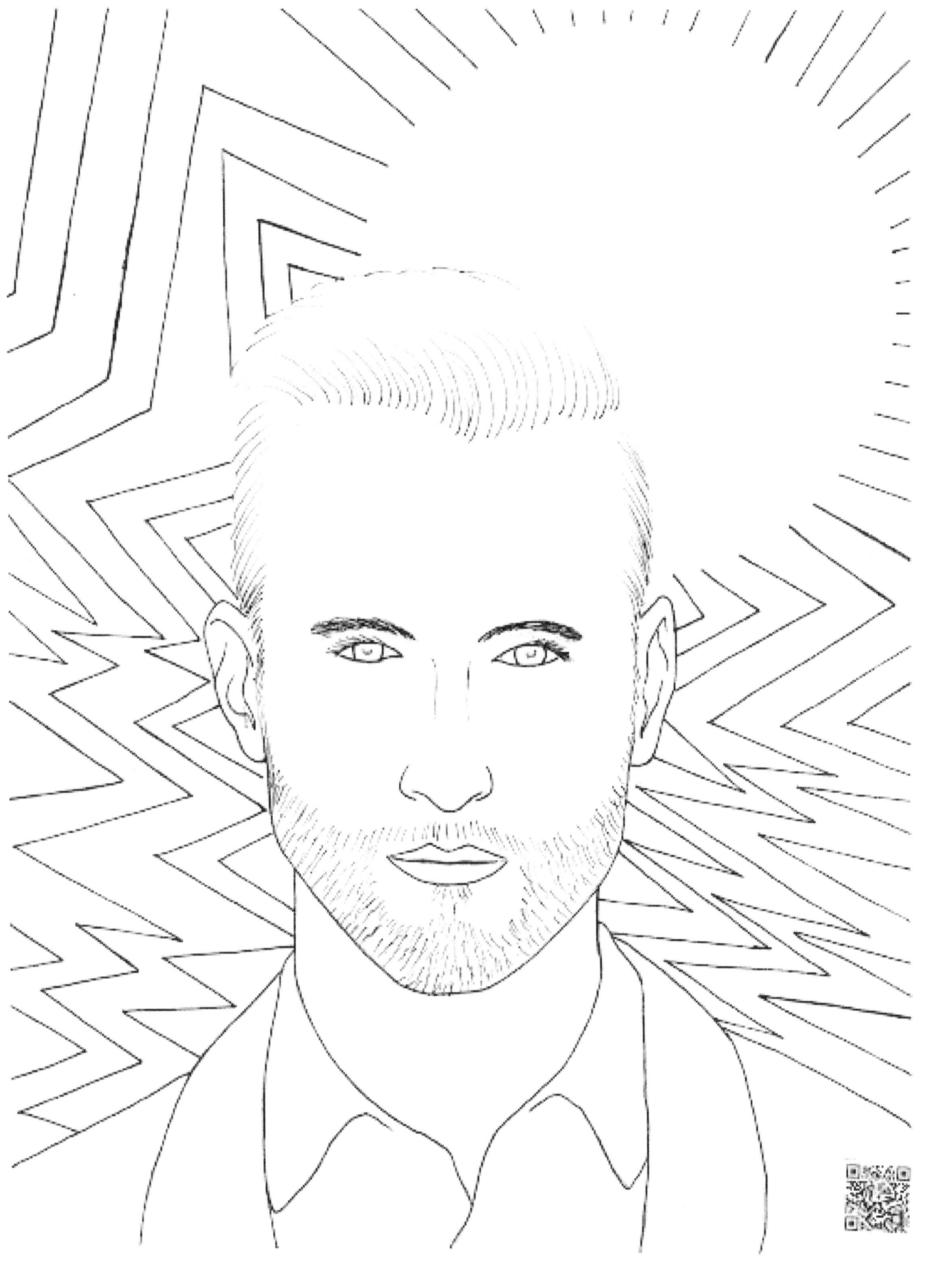

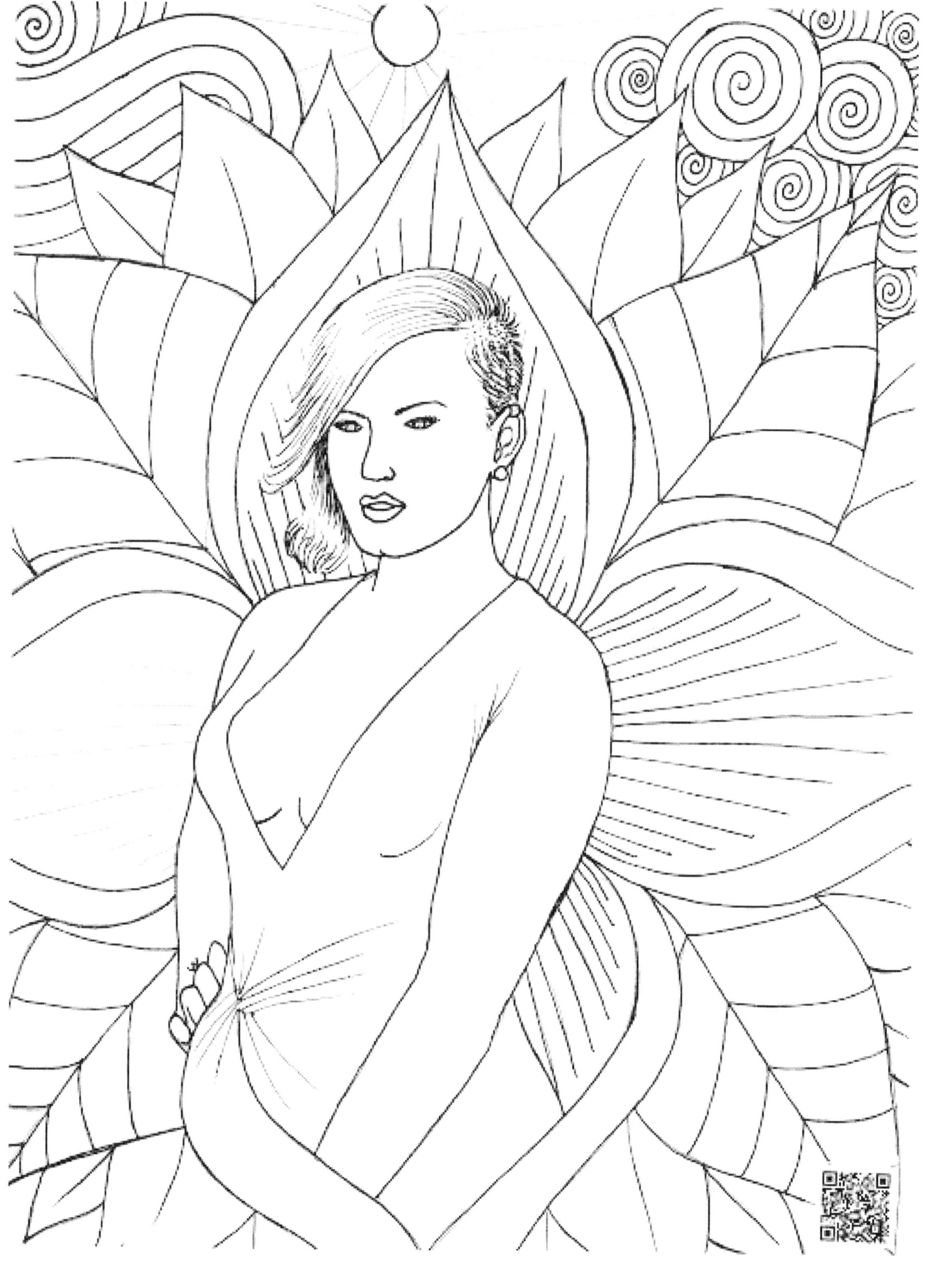

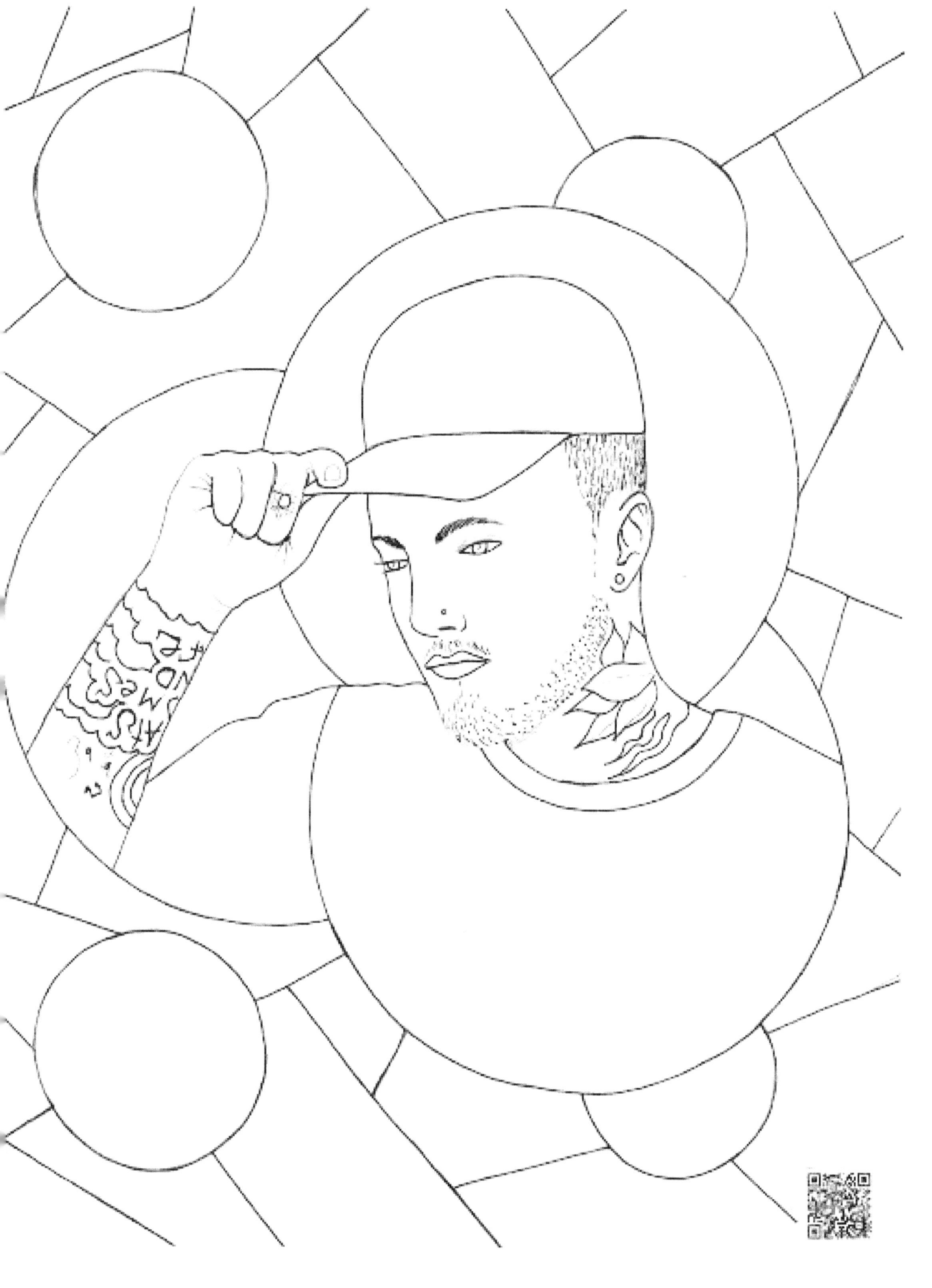

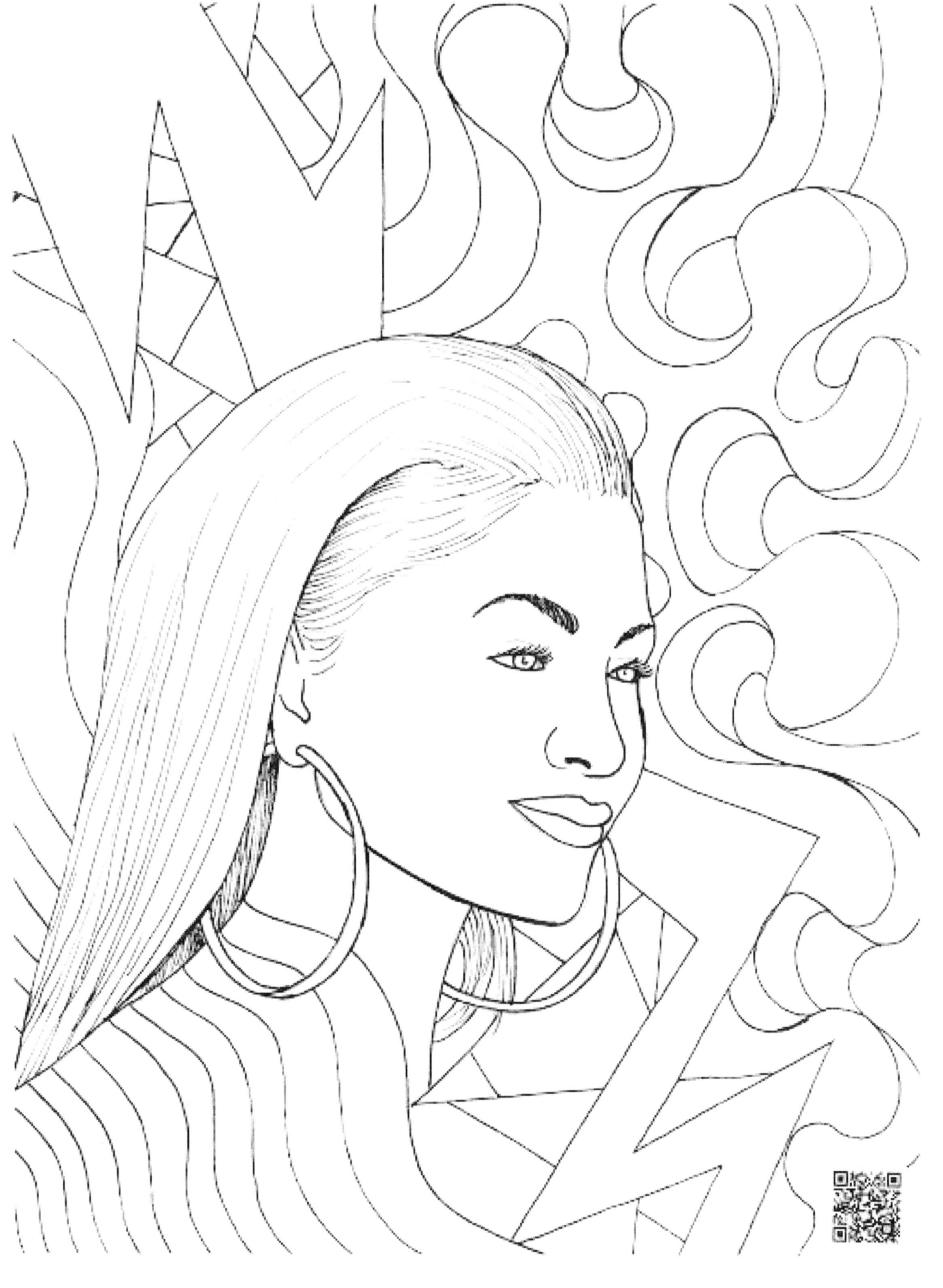

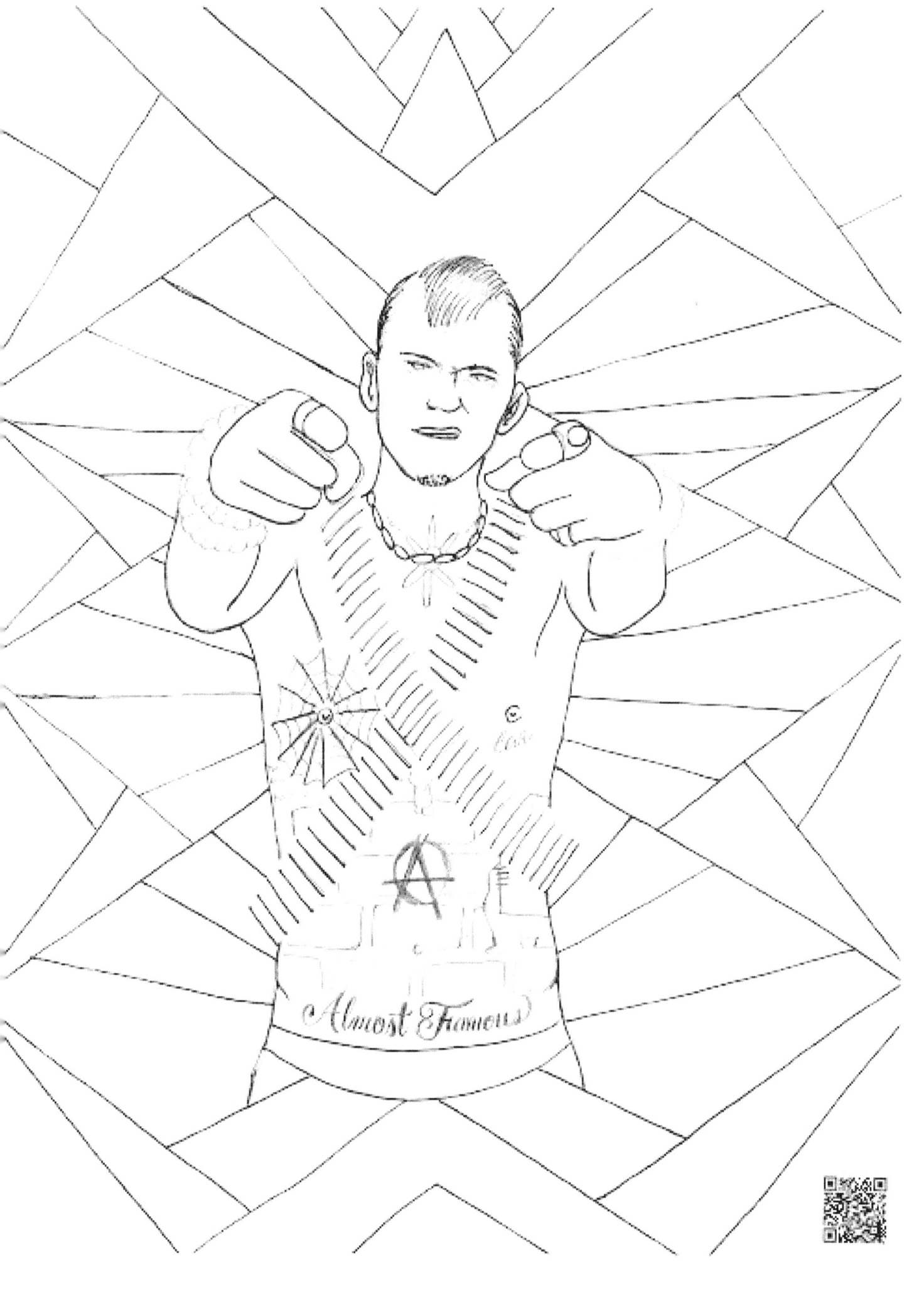

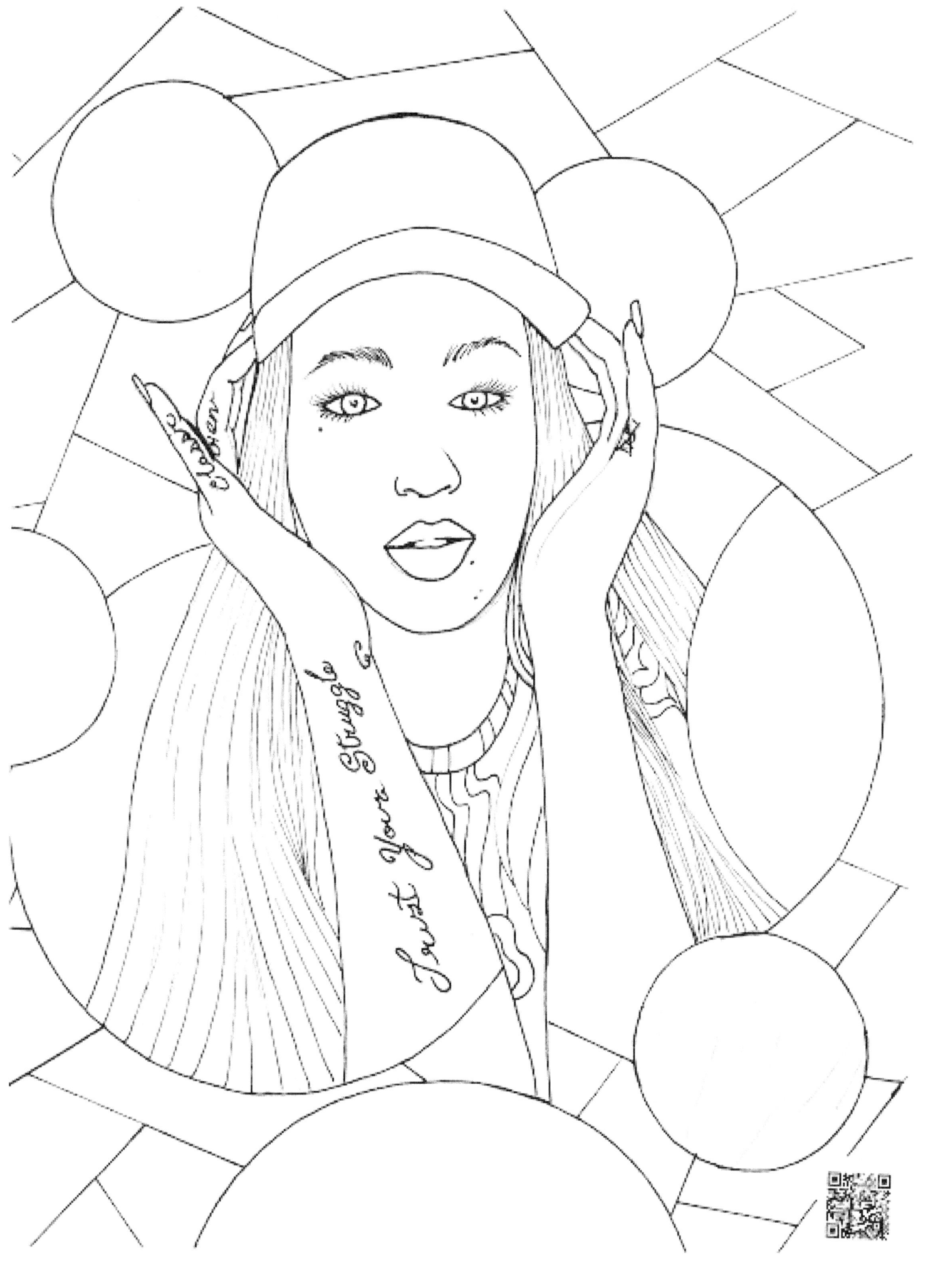

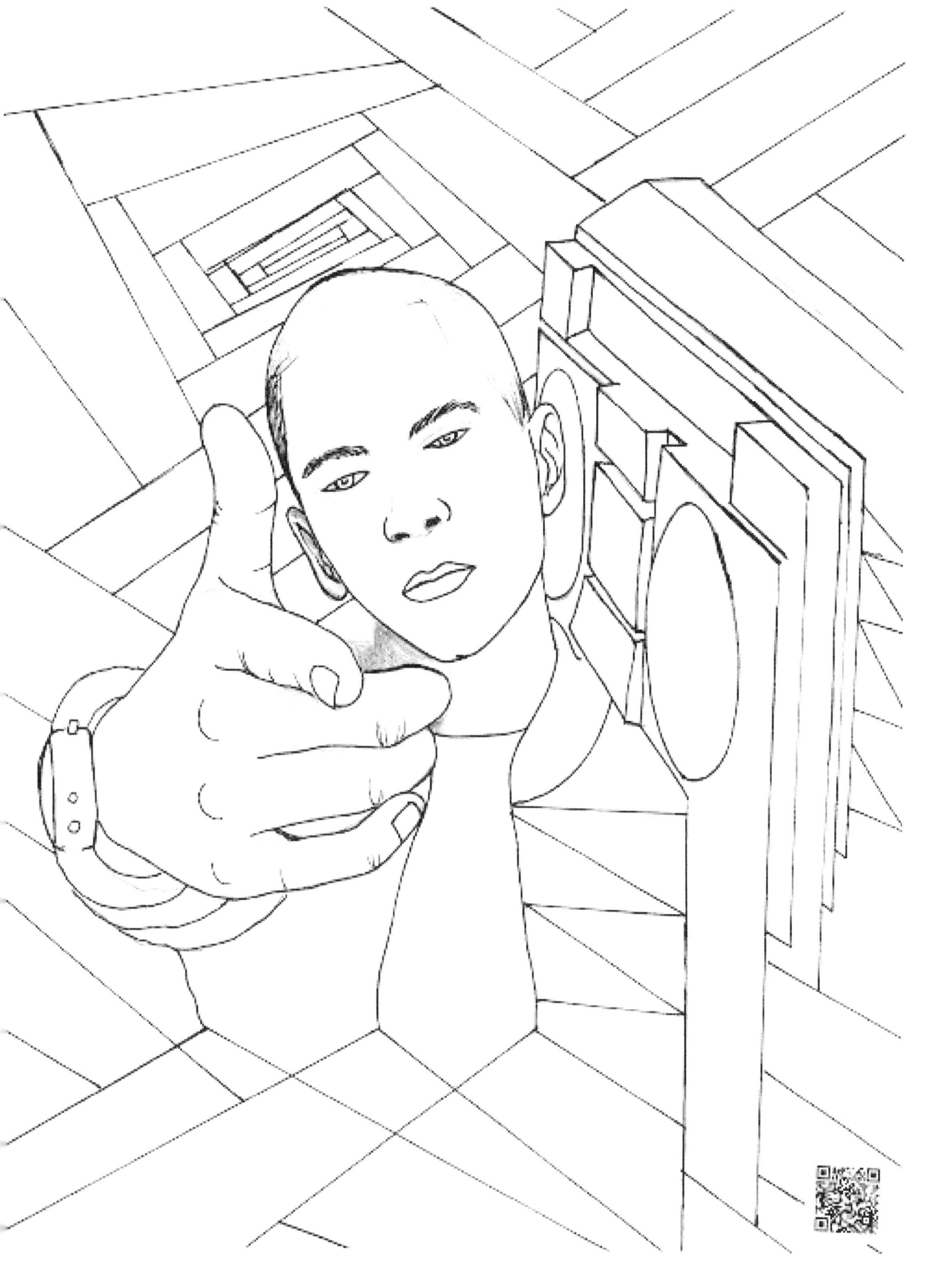

Taylor Swift
Calvin Harris
Katty Perry
Nick Jonas
Ariana Grande
Sam Smith
Selena Gomez
21 Pilots
Miley Cyrus
Justin Bieber
Britney Spears
Justin Timberlake
Amy Winehouse
Adam Levine
Demi Lavato
Mac Miller
Zendaya
Machine Gun Kelly
Iggy Azalea
Eminem

For more information on our Annual Coloring Contests follow us on Instagram @advancedcoloring or scan QR code below

Illustrator: Damion C Jones Jr
To Join Our Mailing Lists Email
advancedcolor@gmail.com

www.ingramcontent.com/pod-product-compliance
Lightning Source LLC
Chambersburg PA
CBHW080522190526
45169CB00008B/3021